A souvenir guide

Sheffield Park and Garden
East Sussex

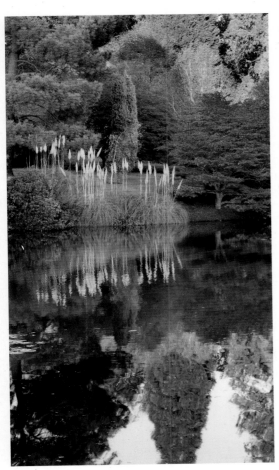

National Trust

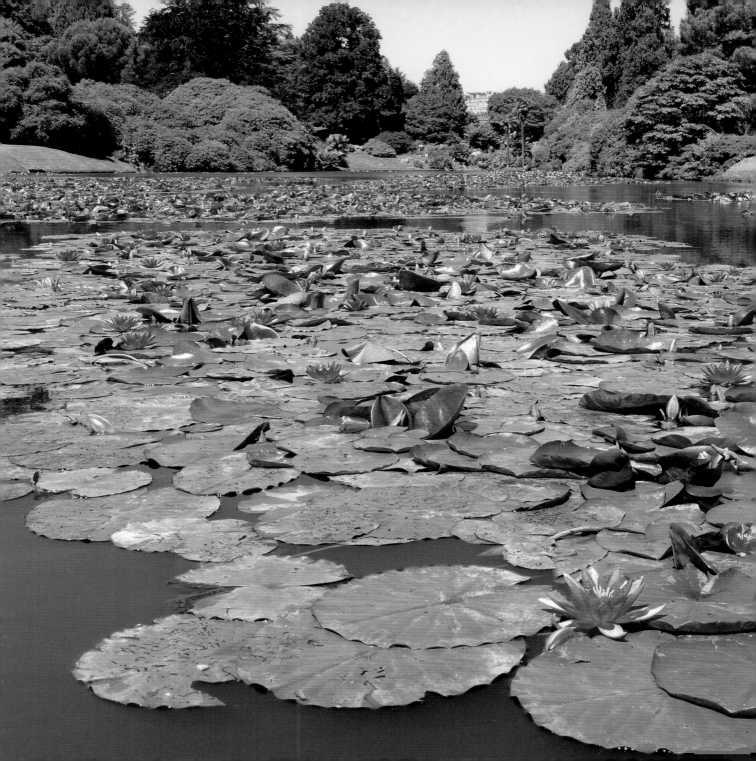

A Place of Light and Water

An ancient estate, once the gift of kings, lies in the East Sussex countryside bounded to its south by the River Ouse. Today Sheffield Park has at its heart a garden whose beauty attracts visitors from around the world.

Water is the life force of this magnificent garden. The natural springs welling up through the ground and Arnos Brook, which flows through its 49 hectares (120 acres) to join the River Ouse, have been harnessed to create pools and ponds. Over three centuries owners have dammed, contained and directed the water, made paths and walkways, and planted beautiful, often rare, trees and shrubs.

Colour spills from the land into the water. In spring the brilliant blooms of rhododendrons dance on the banks, their images reflected on Sheffield Park's watery surfaces. The reds, golds and butter-yellows of autumn are mirrored, and so doubly beautiful, in its lakes and pools.

Water flowing through and around the garden turns it into an ever-changing paradise. It is a place of many moods, sometimes tranquil, sometimes dramatic as wind and rain disturb its landscape, both real and reflected. Clouds, gleams of sunlight and the sudden shadows of birds throw their images fleetingly onto the lakes, and then are gone.

Successive owners refined their relationship with the water, investing meaning in the shape of the ponds, cascades and falls. For the delight of those who walked in the gardens, they planned with care, planting trees and flowering shrubs on the banks and close to the water's edge.

Origins
William the Conqueror, newly victorious in 1066, lost no time in dividing up his English kingdom and giving large areas to his trusted supporters. His half-brother, Robert, Count of Mortain and Earl of Cornwall, received the so-called 'Rape of Pevensey' which contained the estate of Sheffield Park. This part of the 'rape' or ancient division is called 'Sifelle' in the Domesday Book, meaning a place cleared for sheep to graze.

Opposite Water lilies on Middle Lake

At the heart of history

The oldest recorded living tree in the garden is an English oak, *Quercus robur*, reliably dated to 1485. This was the year Henry VII seized the English throne at the Battle of Bosworth, establishing the Tudor dynasty that was to last for more than a century.

His son, Henry VIII, stayed at Sheffield Park in 1538 to hunt deer. The estate was then owned by Thomas Howard, Duke of Norfolk, Anne Boleyn's uncle and one of Henry's leading councillors. Anne was not present – she had been executed in 1536.

The deer park was established much earlier in the 1200s. In 1264 the whole area became engulfed in a rebellion led by Simon de Montfort, 6th Earl of Leicester, whose army of knights fought against Henry III at Lewes. De Montfort's army set up camp at nearby Fletching Common and spent the hours of darkness before the fight praying and receiving the sacrament in the Church of St Andrew and St Mary the Virgin. Today its spire can be seen from Sheffield Park and Garden.

Fletching Church

The High Sheriff of Surrey and Sussex, Richard Leche, leased Sheffield Place, as the estate was known, in the 1500s. He died in 1596 and is buried in Fletching Church where a monument shows life-size images of Richard and his wife, Charitye. The small skull between them indicates the death of a child.

Simon de Montfort won the battle and, for a short while, held power in England, establishing a parliament for discontented barons to air their grievances. The following year he lost his life at the Battle of Evesham.

Aristocratic owners, including Howards, Sackvilles and Nevilles, came and went over the centuries. In 1744, Sheffield Park passed to the De La Warrs who were the first owners to make it their principal home. Surveys of the estate were made and we can see that the substantial mansion of the day was approached from the north by avenues of oak and ash trees. Chestnuts, walnuts and cherry trees guarded the eastern entrance. A 1745 map shows a large kitchen garden, a formal flower garden, orchards, a hop-growing area, stables and a farm. The only water identified is a small stream running through the grounds. Sometime in the next 30 years this was to change. In 1770 John Baker Holroyd paid £30,900 for the estate. A survey map drawn four years later shows a huge lake towards the east. Sheffield Park's long romance with water had begun.

Opposite Thomas Howard, Duke of Norfolk by Hans Holbein the Younger, 1539

Below Survey of the demesne of Sheffield Place, the seat of John Baker Holroyd, esq, by Peter Bernard Scalé, 1774; ESRO AMS 6970/4/1

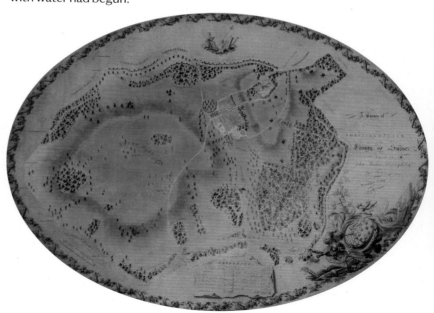

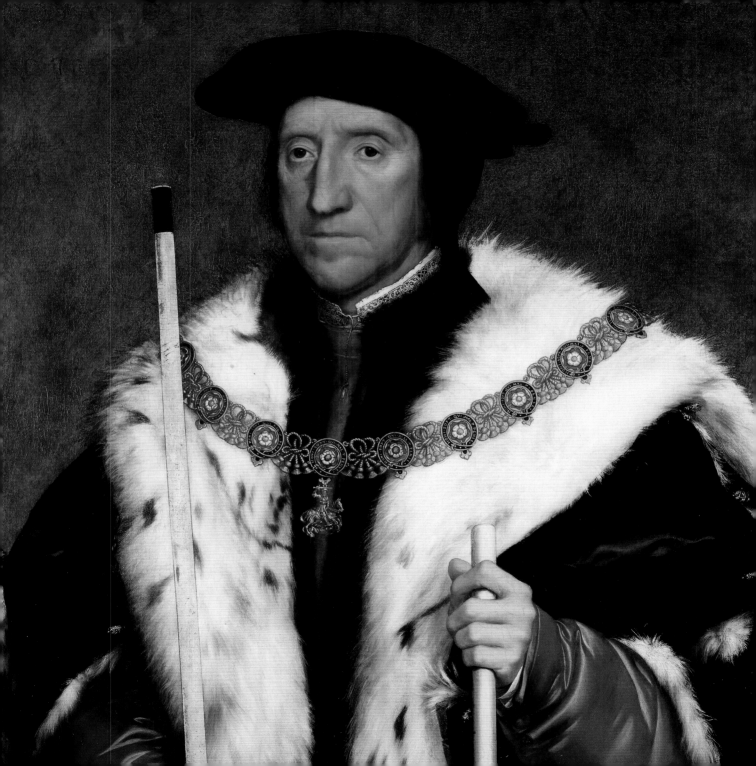

A country retreat

In 1770 Sheffield Place became the property of John Baker Holroyd (1735–1821) – later 1st Earl of Sheffield – an ambitious and upwardly mobile man, married to a wealthy young heiress named Abigail Way. They were an energetic, intelligent and sociable couple. At the time Sheffield Park came into their possession, they were about to have their first child.

The Holroyds set about restoring, rebuilding and designing new features to reflect their comfortable and hospitable lifestyle. Money being no object, they were able to indulge in the showy and extravagant. The most fashionable architect of the day, James Wyatt, was engaged to remodel the house. Leading landscape designers, including Lancelot 'Capability' Brown, were commissioned to shape the grounds, walks, gardens, water features and parkland.

Sheffield Place was the Holroyds' second home, the country retreat where they could entertain politicians, the aristocracy and leading figures from the worlds of science and the arts. From 1789, Sheffield Place would also become a refuge for *émigrés* escaping the French Revolution.

Right An 18th-century watercolour of Sheffield Place

The estate – with its farms, productive land and large amounts of timber – provided employment for the nearby villages and a large income for the new owners. By the end of the 1700s, Sheffield Park could look forward to a promising future. The house, its gardens and parkland became the focus of social life in the area, providing entertainment and enjoyment for the family, their friends, their tenants and other local inhabitants.

the house to the pitch were created; the ponds, built by his grandfather, were made dramatic with sparkling falls and cascades. Sumptuous cricket teas were offered in the three pavilions next to the pitch. Here the home team, made up of such greats as W.G. Grace, C.B. Fry and K.S. Ranjitsinhji, played visiting teams including the touring Australians.

Unmarried and deeply in debt, the 3rd Earl died in 1909. The earldom died with him but the garden he left behind – as we shall see later – was exactly what the next owner, Arthur Soames, would need to create his own garden paradise.

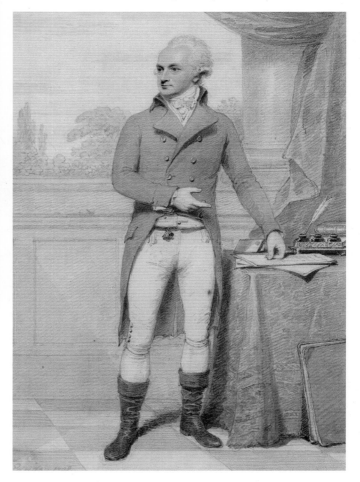

When money flowed like water

Extravagance reached new heights during the time of the 3rd Earl, Henry North Holroyd (1832–1909). His passion, which eventually eclipsed all other interests, was for the game of cricket. Promotion of the sport was the force behind his expensive improvements to the garden and parkland. Here he entertained thousands of spectators to watch thrilling matches on his own cricket pitch. Views from

An English Landscape

When John Baker Holroyd took possession of Sheffield Park in 1770, Lancelot 'Capability' Brown was commissioned to turn the garden, parkland and wider estate into a perfect English landscape. Brown's gently rolling and curving vistas exactly suited Holroyd's aspirations to improve his pleasure grounds and create a model farm.

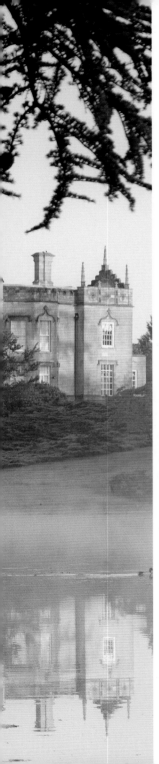

Fashionable architect James Wyatt set to work on the old Tudor house, transforming it into an elegant Gothic-style mansion that rose from the twin quadrangles which had formed the original foundations. John Holroyd was a talented man from a well-connected family with roots in Yorkshire and Ireland. Having served in the Royal Foresters (21st Light Dragoons) for three years, he – in common with many wealthy young men of his day – embarked on the 'Grand Tour' enjoying the classical sights and social delights of Europe. In Lausanne, in 1764, he met writer and historian Edward Gibbon and started a friendship which was to be of enduring importance to him and his family for 30 years.

A life in politics

John Holroyd's energy must have been astonishing. In 1780, now back in the army, he played a major part in suppressing the Gordon Riots when anti-Catholic protestors stormed the Bank of England and the House of Commons. In the same year he became a member of parliament, representing Coventry.

A day in the countryside

Sheffield Place soon became the favourite residence of the Holroyd family whose London house was in Downing Street. In 1786, John's elder daughter Maria Josepha, a young lady of 16 and the author of hundreds of letters to her aunt 'Serena' (Sarah Martha), sings its praises. Writing from London, she muses on the joys of her country home, the pleasure of riding her pony, Pearl, and her pride that when at Sheffield Place she is allowed to dine and sup downstairs. 'I feel myself more of a Woman there,' she writes. In April that year, after describing the joys of her

'farming rides' over 'Ploughed Fields and Dirty Lanes' with her father, she gives Serena an account of a typical day, where breakfast is taken at 11am and dinner at 4 o'clock. Long walks early and late, sessions on the harpsichord or at her easel, an hour of translation (she was fluent in French), and spells of reading, piano practice and needlework with her pet bullfinch on her shoulder, fill the rest of the day. A game or two of backgammon, a tea-drinking session at 7pm and 'our little bit of Supper' at 10pm, completes a full day in the country.

Farming interests

Lord Sheffield's parliamentary duties did not prevent him from experimenting with progressive farming methods at home. He kept a large flock of Southdown sheep, devoting himself to improving the quality of wool and meat by cross-breeding. He became President of the Board of Agriculture in the 1800s.

Left The mist rising over Ten Foot Pond with Sheffield Park House in the distance

An unlikely friendship

One of the great history books of the English-speaking world was mostly written in the comfort of the new library at Sheffield Place.

John Holroyd and Edward Gibbon were born two years apart in the 1730s. Holroyd was tall, wiry and energetic. Gibbon was short, rotund and not too fond of exercise. Holroyd was a family man, deeply attached to his wife Abigail ('Sally') and their two daughters, Maria and Louisa. Gibbon remained a bachelor. They met in Lausanne, Gibbon's adopted home, and began a

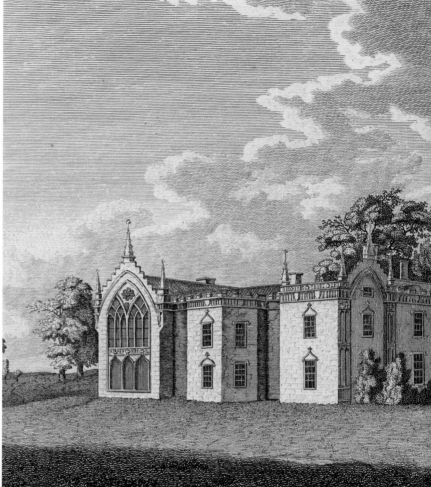

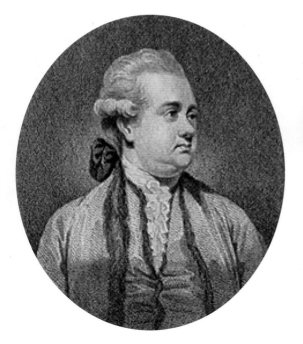

conversation that lasted 30 years until Gibbon's death in 1794. Gibbon was an entertaining conversationalist, not afraid of expressing controversial views and the two, although disagreeing frequently, enjoyed engaging in philosophical argument. In 1764, the year their friendship began, Gibbon visited Rome – possibly in the company of John – and, 'musing among the ruins of the Capitol', vowed that the 'eternal city' would be the subject of his life's work.

Above Etching of Sheffield Place by R. Godfrey, c.1778

Left Edward Gibbon (1737–94)

Gibbon's masterpiece, *The History of the Decline and Fall of the Roman Empire*, published in six volumes over a period of 12 years, was an enormous success. During the Holroyd family's early years at Sheffield Place, Gibbon, by now living and writing in London, visited often, telling in his memoirs of finding himself 'at Lord Sheffield's house and library, safe, happy and at home'.

Right Edward Gibbon's *The History of the Decline and Fall of the Roman Empire*

Adventure across Europe

In June 1791, two years after the French Revolution and a few days after the arrest of King Louis XVI and Queen Marie Antoinette, the intrepid Sheffields left their country home to travel across Europe – via the French capital – to visit Gibbon at Lausanne. Maria, Lord Sheffield's daughter, playfully reassured her aunt: 'I am sure Papa will not run any risks with his whole family about him and, indeed it would be unkind to you, as, if we were all exterminated you must marry immediately.'

The Holroyds stayed in Paris for a couple of weeks before travelling on to Lausanne, where diversions included a visit to Chamouny (Chamonix), exploring the countryside by mule and on foot, and enjoying balls and assemblies. Maria's long letters home express worry at developing unrest across Europe as they travel home by way of Berne, Basel, Strasbourg, Coblentz, Bonn, Brussels and Calais. The family were back in England by early November.

A sad loss

When Gibbon died in 1794, the Holroyd family's grief was strong and they interred their friend in their family mausoleum at Fletching Church. Lord Sheffield, who was Gibbon's literary executor, edited the historian's papers into *Memoirs and Writings*. Of their friendship, Gibbon had written, 'I have sometimes wondered how two men, so opposite in their tempers and pursuits, should have imbibed so long and lively a propensity for each other.'

The 'placemaker'

Capability Brown had been working as a landscape architect of great repute for three decades by the time he was employed at Sheffield Park in the 1770s. Frustratingly, his creativity was not matched by efficient record-keeping and there is no written note of his plans or of the work carried out here.

We know he was consulted by John Holroyd in 1775 and that he paid several visits to Sheffield Park. A large lake had already been made at the eastern end of the garden, probably by the 2nd Earl De La Warr, and it seems that Brown focused his plans on this area. In 1776 he sent his surveyor and draughtsman, John Spyers, to map the project – which was probably to divide this single sheet of water into two, creating the Upper and Lower Woman's Way Ponds.

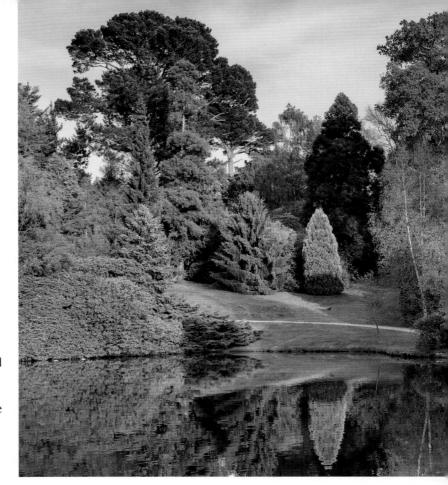

It is likely that Brown developed the network of paths between the water and the house, and cleared the banks sloping down to the lakeside to introduce his signature clumps of bare-stemmed trees. These were planted in groups of three or five, or sometimes dug in as a 'bundle' of saplings.

Above Reflections in Upper Woman's Way

Left Capability Brown (1716–83) by Nathaniel Dance, c.1770

Shaping landscapes
Capability Brown was so called because of his habit of assuring clients that their land had great 'capabilities'. He preferred to be known as a 'placemaker' rather than a landscape designer.

The architect

James Wyatt, who had previously worked with Brown, was a rising star when called in to remodel Sheffield Place. The great house, with its stupendous east-facing window rising through two floors and giving views across the water to the village of Fletching, still plays its part as sentinel to the garden and parkland. It continues to be privately owned.

Wyatt, trained in Italy, saw instant success on his return to England with a design for the Oxford Street Pantheon, a place of public entertainment notable for its enormous domed rotunda. He must have paid his first visit to Sheffield Park around the time the Pantheon was opened in 1772.

His style was romantic, veering towards the classical but more often – as displayed at the Holroyd's new mansion – the fashionable Gothic Revival. If there were any doubts about Wyatt's interpretation of the Gothic, these must have been dispelled by the favourable comments of the distinguished landscape designer Humphry Repton, who also had a hand in shaping the garden and park: 'The most correct specimens of true Gothic... are Sheffield Park and Nacton, both old houses altered by James Wyatt Esq.'

Above James Wyatt (1746–1813) by Joseph Singleton, 1795

Below The Gothic window at Sheffield Park House

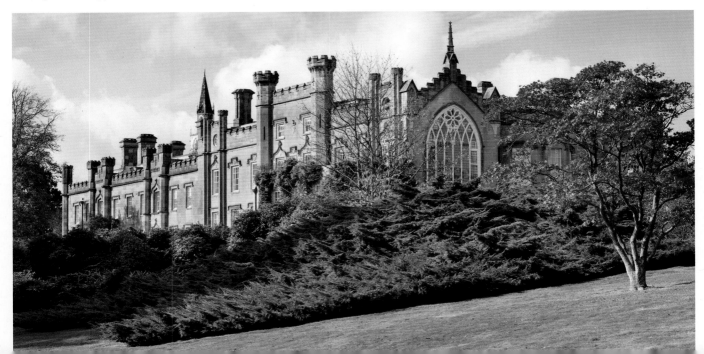

A watery puzzle

The story of how the water, flowing through the park and garden, came to be gathered into ponds and pools is frustratingly difficult to document. We know that Humphry Repton, as eminent a garden designer as Capability Brown, worked here, but the extent of his contribution is not known.

Records show he visited several times in 1788 and 1790 and it is thought he created four large ponds between the house and Brown's two lakes on the eastern boundary.

However, a letter from Maria Holroyd to her Aunt Serena in 1786 and an account by William Cobbett, rural reformer and writer, suggest that there were ponds close to the house before Repton's involvement. Attempting to persuade Serena to visit, Maria writes of the 'new things to amuse you… To come nearer the House, there are four young Swans, upon the Pond before the Windows…which will be very pretty objects from your Room.' Two years later Cobbett writes of riding through Lord Sheffield's grounds '…and around the house, which is placed pleasantly, and surrounded greenly, and by some good trees, with lakish ponds in front'.

Farmer Sheffield's model farm

In 1782, after John Holroyd had been elevated to the nobility (as Lord Sheffield), his sister Serena referred to him as 'Farmer Sheffield' when writing to her niece and his daughter, Maria, then 11 years old.

Lord Sheffield was passionate about his farm, his sheep and cattle, the arable crops and the estate timber, grown commercially. Sheffield Park, its house, garden, farmland and woodland represented probably the most satisfying part of his life; he and his family spent the greater part of their time there.

When he engaged Capability Brown he must have known of the latter's belief in the beauty of farmland as part of the landscape and his ability to integrate working farms, great houses, formal and informal surroundings into one whole – simple elegance blending happily with the countryside.

He asked James Wyatt to design the farm buildings, insisting that they should be 'vehicles for progressive architectural and agricultural feeling'. Thus the traditional barn with a grain threshing floor was to be made redundant in favour of buildings to house new machinery which did the job more efficiently.

Right **Bright autumn colours reflected in Middle Lake**

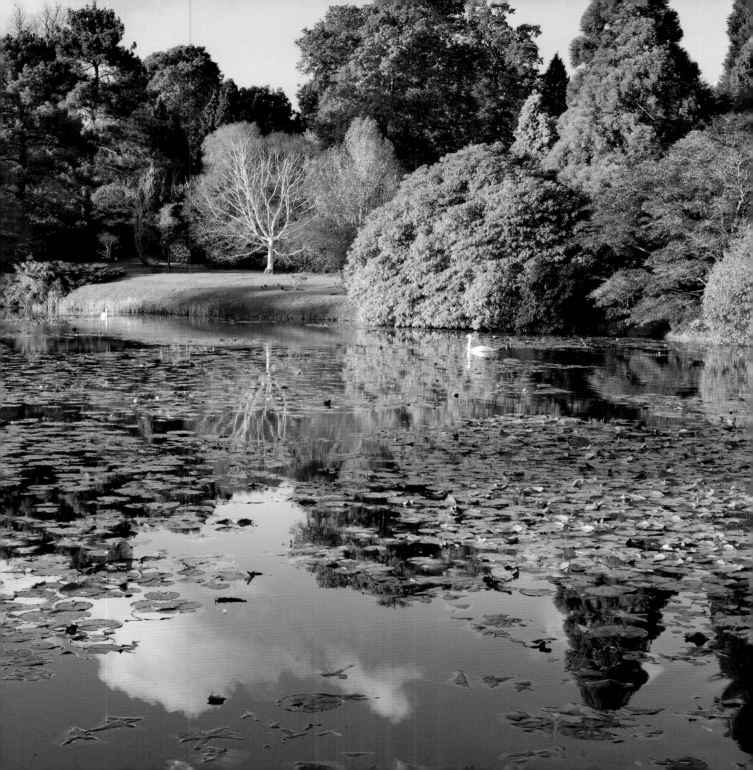

Lady Nature's Second Husband

Some believed Lancelot 'Capability' Brown was England's greatest gardener. Others derided his naturalistic landscapes. The satirist, Richard Owen Cambridge, wanted to die before him in order to 'see heaven before it was improved'.

Brown, whose working life as a garden boy began in the Northumberland village of Kirkharle, instinctively understood how to pull all the components of an enormous park together to create a harmonious whole. His approach was totally different from the previously admired but massively labour intensive formal gardens of the 1600s and early 1700s.

He remodelled the landscape, so that the view from the client's house exposed his 'improved' countryside: sweeping lawns close to the building sprinkled with small clumps of three or five trees, lakes and ponds, and beyond them fields with grazing cattle and sheep. The rural idyll was made complete with vistas of farmland and decorative agricultural buildings.

Below *The Great Water*, watercolour by Samuel Hieronymus Grimm, 1787, with the spire of Fletching Church in the distance

Right Lower Woman's Way Pond, the part of the garden most resembling the original Capability Brown landscape

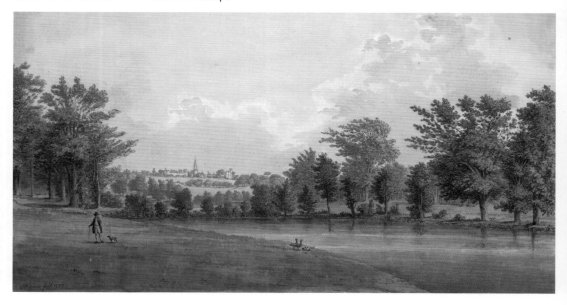

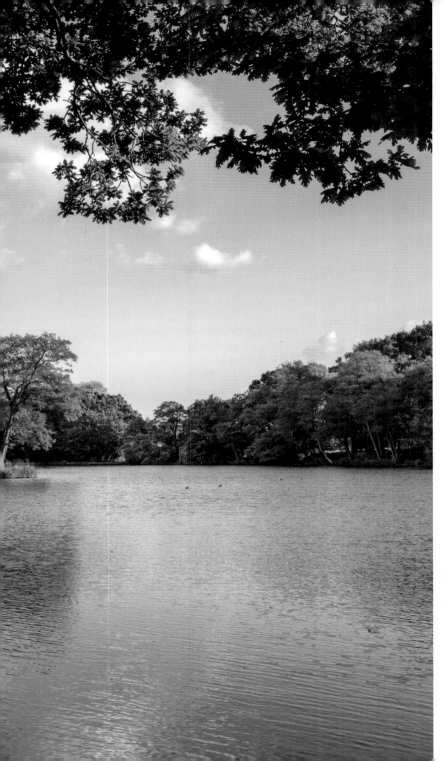

Brown would ride around the estate on horseback, learning its topography, working out where to make dams to form lakes. He then planned the changes and had them sketched by his surveyor, John Spyers. Next, a team of water engineers, carpenters, levellers and plantsmen set to work under the eagle eye of William Ireland, his overseer. Brown rarely wrote down details of the work to be undertaken, preferring to instruct his team directly and see the job through to the finish.

Brown's grammatical gardening

Because Brown kept few written records, it is hard to know exactly where his team worked at Sheffield Park. However the evidence of his hand is all around: groups of trees planted on the banks of the lakes; paths always leading to and from the house; the parkland rolling gently into the distance, its undulations enhanced by clumps and small copses. It seems that Brown achieved this effect by judicious felling rather than by new planting; it was an area that was already heavily wooded.

He likened his methods to a grammatical composition, explaining his work at Hampton Court to writer and philanthropist Hannah More in 1782. 'There… I make a comma, and there where a more decided turn is proper, I make a colon; at another part, where an interruption is desirable to break the view, a parenthesis, now a full stop – and then I begin another subject.'

An epitaph
Brown died, as the result of a fall, in 1783. He was 67. Historian and man of letters Horace Walpole wrote to his friend and correspondent Lady Ossory: 'Your Dryads must go into black gloves, Madam. Their father-in-law, Lady Nature's second husband, is dead! Mr Brown dropped down at his own door yesterday.'

Picture-perfect plans

In 1791 another landscape designer, Humphry Repton, drew a charming view of Sheffield Place, the Gothic mansion guarded by leafy oak trees and a cohort of deer with fully grown antlers. A carriage rumbles slowly along a winding way between two massive trees.

Humphry Repton, often seen as successor to Brown and frequently called in to continue or alter his landscaping, was an up-and-coming name in the world of landscape gardening, a term he coined for himself. His working methods differed from those of Brown in that he used his considerable skill as an artist to draw 'before' pictures of the landscape which could be overlaid with drawings showing his 'after' proposals.

These were bound into a beautifully produced book, covered with his trademark red binding. Repton charged his clients for the books and the designs but left them to organise the work themselves.

A letter written by Repton towards the end of 1794 expresses his regret that Sheffield Place '…is about the only place of consequence on which I did not deliver my opinion in a Red Book'. He clearly knew it well, commenting favourably on Lord Sheffield's new mansion and despairing at the rate of growth in the garden and parkland: 'Such is the power of vegetation at Sheffield Place, that every berry soon becomes a bush, and every bush, a tree.' This, he complained, obliterated the natural shape of the valley.

Above Humphry Repton (1752–1818), who remodelled the garden as a young man

Below An example of a Repton 'Red Book', showing proposed transformations at Wimpole, Cambridgeshire. The 'after' view is shown under the flap

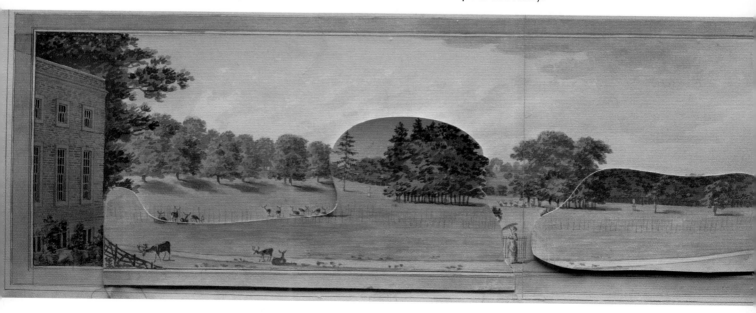

Rocks and water

Almost one hundred years later the 3rd Lord Sheffield, Holroyd's grandson, engaged another fashionable gardening company to make extensive alterations to the lakes and ponds. James Pulham and Son were the people to call in when rocks and water were to be combined. The basis of their fame was an artificial rock, made to a secret recipe; it was used in rock gardens, ferneries, waterfalls and grottos – all the 'picturesque' features so beloved of the Victorians. 'Pulhamite', which looked like rough sandstone, could be made to create waterfalls and cliffs. Water was piped through and thus cascades were created.

The 'Pulham Falls' linking Ten Foot Pond and Middle Lake were built between 1882 and 1885. Because there was plenty of natural stone at Sheffield Park, artificial Pulhamite was not required, but the company designed the layout of the cascade and engineered the machinery necessary to control the flow of water between the pools. Contemporary reports waxed lyrical about the new water works. 'On each side of the main cascade, pools have been formed, surrounded by massive rocks, some of the pieces of stone weighing five to six tons, artistically planted with alpine shrubs and ferns', enthused one local newspaper in 1885.

PULHAM & SON.
GARDEN SPECIALISTS.
ESTD 1820.

TELEPHONE 5141 CENTRAL.
TELEGRAMS 'PULHAMITE LONDON'

71 NEWMAN STREET
OXFORD STREET.
LONDON . W.

AND AT BROXBOURNE.

Above Pulham & Son were one of the most prestigious landscape gardeners of the 19th century

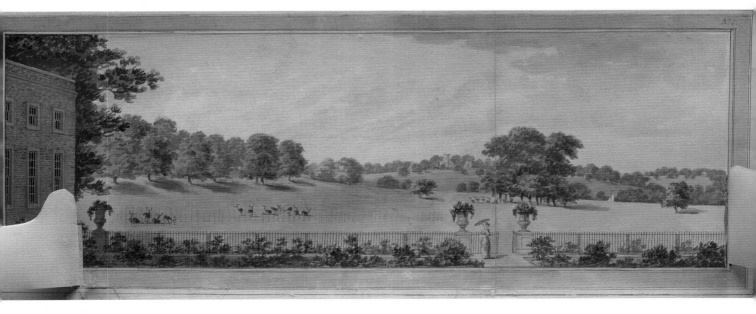

Letters from Maria

Maria Josepha Holroyd was born in 1771, shortly after her father bought their Sussex country home. She was intelligent, well-educated and a committed letter writer.

Maria's most frequent correspondent was 'Serena', her aunt, Sarah Holroyd, who lived in Bath. Another was Ann Firth, sometime member of the household at Sheffield Place.

In September 1786 Maria tells her aunt of the new herd of deer in the park and complains of the 'great undertaking' of making a 'Gown in Spots'. With typical humour she adds, 'I do not despair of finishing it in a year or two, and I hope the Fashions will have the complaisance to wait for me.' She also mentions being 'tired' of Margaret Nicholson – a mentally disturbed woman in the news for attacking King George III, who claimed she was the rightful heir to the throne.

Right Maria Josepha Holroyd and her younger sister Louisa as children, 1793

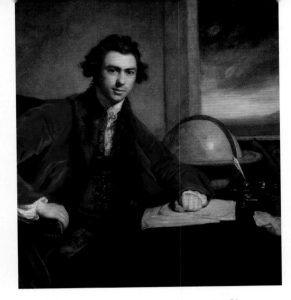

The following year we learn of botanist Sir Joseph Banks's stay at Sheffield Place and that Edward Gibbon was expected soon. 'Papa is going to Town this morning to meet Mr Gibbon… I shall be very glad to see him… We are all turned Botanists since Sir Joseph Banks came.'

A death and three marriages

The Sheffields were generous hosts and the house was often full. Maria, writing 'in the Library just before Supper, surrounded by divers Tongues' apologises to Serena that her 'Ideas are not very clear', but she acknowledges that the 'Fidler' brought by one of the guests is 'very agreeable, as he accompanies one on the Pianoforte every evening'.

In April 1793 Maria's parents were in London, supporting French refugees driven there by the Revolution. During their stay Maria's mother Abigail, Lady Sheffield, had spent time at Guy's Hospital, ministering to the sick. Maria wrote from Sheffield Place to Ann Firth, who is away visiting relatives: 'Mama has been unwell since we left town – Fainting and very Sick.' Two days later, Lady Sheffield was dead. Edward Gibbon left his Lausanne home immediately to comfort his friends.

In December 1794 Lord Sheffield remarried. Maria met her new stepmother, Lucy Pelham, on New Year's Eve and was delighted. She wrote to Ann Firth of the 'many and nameless instances of delicate attention and Feeling which I have perceived in her conduct towards us all, but me in particular…and which in these few hours have opened a prospect to me of greater domestic comfort than I have ever yet known.'

A beloved stepmother

Maria and her family grew to love their stepmother. Their world was again shattered in January 1797 when she too died. By that time Maria had married John Stanley who became the 1st Baron Stanley of Alderley.

Lord Sheffield was married a third time to Anne North (below), daughter of the former Prime Minister, Lord Frederick North, by whom he had a son, George, and a daughter, Anne. In 1816, five years before his death, he was made Earl of Sheffield.

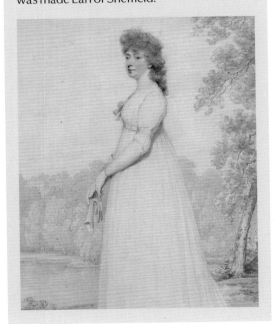

Left Sir Joseph Banks (1743–1820) by Sir Joshua Reynolds, 1771–73. The freestanding globe in this portrait refers to his travels in search of botanical species

Women of Sheffield Park

The clearest voice reaching us over the centuries is that of Maria Holroyd, the bright, witty daughter of the 1st Earl. Her letters reveal much about daily life at Sheffield Place, her family and their friends, but there are other important women in the story of Sheffield Park.

Adventurous Nellie Soames

More than a century after Maria, another writer, Agnes Helen 'Nellie' Soames, was the owner of Sheffield Place. *Polar Gleams* is her account of a voyage she made to the Arctic through the Kara Sea. It describes her visits to Siberian communities and her obvious relish in the company of handsome young Russian men; it shows too the author's lively and enquiring mind. Nellie married Arthur Soames in 1919, when both were middle-aged. He died before the Second World War but she lived almost to her 100th birthday. Nellie and Arthur Gilstrap Soames were childless. The estate was left to Arthur's nephew, whose son, Christopher Soames, became a distinguished politician. He married Winston Churchill's daughter Mary, in February 1947.

Beloved May

The adoption of the grown-up Mabel 'May' Attenborough, daughter of the Fletching vicar, by the unmarried 3rd Earl, John North Holroyd, may have set tongues wagging at the end of the 1700s, but there is no doubt that she was a popular character, organising shows, parties and treats for the neighbourhood. Three years after the Earl's death, at the age of 42, she married Gabriel Roy Fitzpatrick, an officer in the 2nd Welsh Regiment. Just two years later, in 1914, he was killed in action and the village, who had celebrated May's wedding, mourned with her.

Virginia Woolf

Among the many women who visited and loved Sheffield Park were the writer Virginia Woolf and Chief Guide to the Scout and Guide Movement Olave Baden-Powell (née Soames), whose brother inherited the estate. Virginia Woolf, who lived at nearby Monk's House (now also cared for by the National Trust), wrote an essay entitled 'Reflections at Sheffield Park'. In it she described 'the great ponds at Sheffield Place' which 'at the right season of the year are bordered with red, white and purple reflections, for rhododendrons are massed upon the banks and when the wind passes over the real flowers the water flowers shake and break into each other.' She then goes on to ponder how Gibbon would have experienced the garden: 'Did the historian himself ever pause here to cast a phrase, and if so what words would he have found for those same floating flowers?'

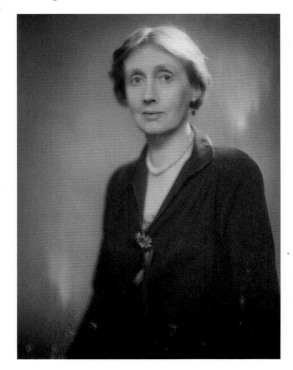

Left In spring, the rhododendrons provide a colourful display

Right Virginia Woolf (1882–1941), who wrote 'Reflections at Sheffield Park'

The Journey of Life

The year is 1886. The morning is warm and sunny, perhaps late May or early June. On the wide terrace in front of the mansion at Sheffield Park stands a plump, bewhiskered gentleman gazing eastwards where the sun has risen over the spire of Fletching Church, visible in the near distance.

Henry North Holroyd, 3rd Earl Sheffield, contemplates the view from his house: swallows swooping and dipping low over the four lakes and ponds, which now assume the shape of a cross; the leafy paths and walks, and the tall trees leaning over the sparkling water. His gaze travels to the church spire marking the site of the family mausoleum, the resting place of his father and brother, his grandparents and, eventually, himself. This design, the cruciform arrangement of the lakes, pointing the way through his peaceful and expensively restored gardens towards the church, represents the Journey of Life and perhaps this crosses his mind.

What is almost certainly on his mind is his splendid cricket ground, famous locally, nationally and internationally, and which he can see from his

Above The 3rd Earl built elaborate pavilions on the cricket pitch to host his society guests

Left A drawing of the 3rd Earl from 1891; few photographs of him exist as he hated having his picture taken

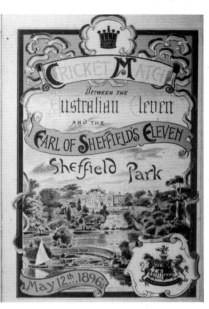

terrace viewpoint. The 3rd Earl's abiding passion is cricket and it seems that the considerable improvements he has made to Sheffield Park since he inherited in 1876 have been for the enjoyment and admiration of those thousands who come to watch some of the most exciting matches in the country.

The game's the thing

The 3rd Earl's increasingly obsessive interest in cricket was fostered by his father who built the first small ground at Sheffield Park in 1845, and on which Henry and his younger brother Douglas played.

When the boys left Eton, Henry did not, like his brother, pursue an academic course. While Douglas enrolled at Christ Church, Oxford,

Henry spent a couple of years in the army in India. After pursuing a diplomatic career in the Crimea, Constantinople and Copenhagen for five years, Henry won the parliamentary seat of East Sussex for the Conservatives in 1857. A few weeks later he became President of the Sussex County Cricket Club.

All the while he was inching back towards Sheffield Park and its cricket ground which had been enlarged and improved in 1855 and where he and Douglas, now studying the law, organised and played in local matches.

Above A menu card for the 1896 match between the Australian touring team and the 3rd Earl's Eleven; the match was attended by the Prince of Wales

The 2nd Earl

Henry North's father, the 2nd Earl, George Augustus Frederick Charles, preferred a quiet life on his Sussex estate. He and his wife, Harriet Lascelles (daughter of the Earl of Harewood), spent much of their time sketching, walking, hunting and hare coursing. Like his father, the 1st Earl, George devoted himself to agriculture. Unlike his father, he did little to maintain or improve the estate. However, he and Harriet were active in the community, buying a house and land for the village school and paying for a new organ for Fletching Church.

Wickets, water and sumptuous extravagance

On his succession in 1876, Henry, 3rd Earl of Sheffield, embarked on an ambitious programme of landscaping, creating more garden from parkland, building new stables and developing the cricket pitch into a world-class ground.

Money was no object as the Earl opened up the hitherto serviceable but cramped pitch, built on a plateau overlooking the Upper Woman's Way Pond in the East Park area of the grounds. Trees were felled, undergrowth cut back and new views brought into focus. As one of the many well-known newspaper reports of the time ran: 'It occurred to the noble Earl that its [the pitch's] commanding position might render available, with careful treatment of the too luxurious growth around it, some charming and diversified views. That thorough success has attended his efforts must be acknowledged by everyone.'

More ground was cleared and levelled, making the pitch three times larger than before. Views of the water, cascades and mansion were revealed. It may have occurred to the 3rd Earl that, with a good pair of binoculars, he would be able to watch cricket from the house.

Pavilions of splendour

Not content with creating a picturesque and sizeable pitch, the Earl ordered the construction of pavilions for the 'gentlemen' and 'players', to provide dressing rooms with 'every convenience' and a large room for Mrs Coomber, the caterer.

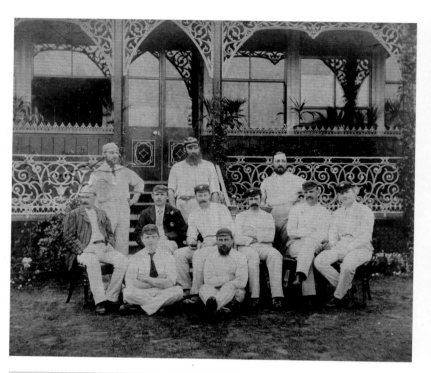

A good all-rounder

The 3rd Earl lived at Sheffield Place with his mother, Harriet, who survived her husband by more than a decade, and his brother Douglas, whose ill health had forced retirement from his practice as a barrister. When Douglas died in 1882 at a comparatively youthful 47, his obituaries mentioned his prowess as a cricketer, as an effective batsman, a fair bowler and an excellent longstop.

Above Lord Sheffield's Eleven in 1884

Right Portrait of W.G. Grace, attributed to Archibald John Stuart Wortley, 1890

Opposite An early cricket match at Sheffield Park

Following page A perfect reflection of autumn colour in the Middle Lake

The crowning glory was the erection, by 1883, of an elaborate pavilion for the Earl and his friends. Built of timber and wrought iron, with a wide garden and shady veranda, the new building, reached by a flight of steps and folding doors, contained a magnificently furnished library and a 'retiring room' with a handsome chimney-piece. A covered spiral staircase led to the roof – a comfortable vantage point for keeping an eye on the game below.

By 1886 a sumptuous octagonal pavilion for ladies was built, completing the trio deemed necessary for the comfort of players and spectators. The magnificent new buildings were in place and the pitch in excellent order, when on 12 May 1884 thousands turned up to watch an All England Eleven, captained by W.G. Grace, take on the formidable Australian touring team in a two-day match. Although the home team lost by an innings and six runs, the match was hailed a huge success and was the first of several against the Australian visitors.

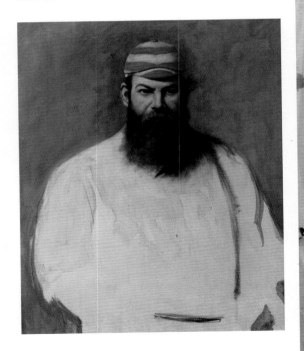

CRICKET.

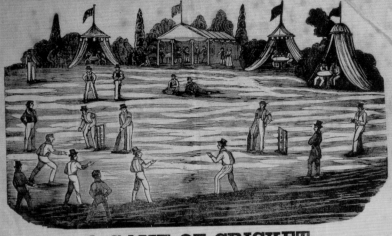

A GAME OF CRICKET

WILL BE PLAYED IN

SHEFFIELD PARK,

BETWEEN

Eleven Gentlemen from FLETCHING and NEWICK,

AND

Eleven Gentlemen from CHAILEY and NEWICK,

ON

Thursday, August 28, 1845.

FLETCHING.	CHAILEY.
VISCOUNT PEVENSEY,	J. BLENCOWE, ESQ.
B. VERRALL, ESQ.	E. VINCENT, ESQ.
E. BLAKER, ESQ.	— WALKER, ESQ.
E. NEWNHAM, ESQ.	MR. OBEN.
MR. HALE,	— PEACOCK.
— COMBER,	— DRAWBRIDGE,
— FRIEND,	— WESTON,
— KENWARD,	— GUY,
— GILBERT,	— WATERS,
— WESTON,	— NORMAN,
— AWCOCK,	— MARTEN,
— LENEY,	— COPPARD.
— FULLER.	— BEARD.

The Wickets to be pitched at Ten o'clock, A.M.

A Cold Collation will be provided on the Ground, by the Public's obedient Servant,

JAMES COMBER, Sheffield Arms Inn, Fletching.

J. HARBERD, PRINTER, FISHER STREET, LEWES.

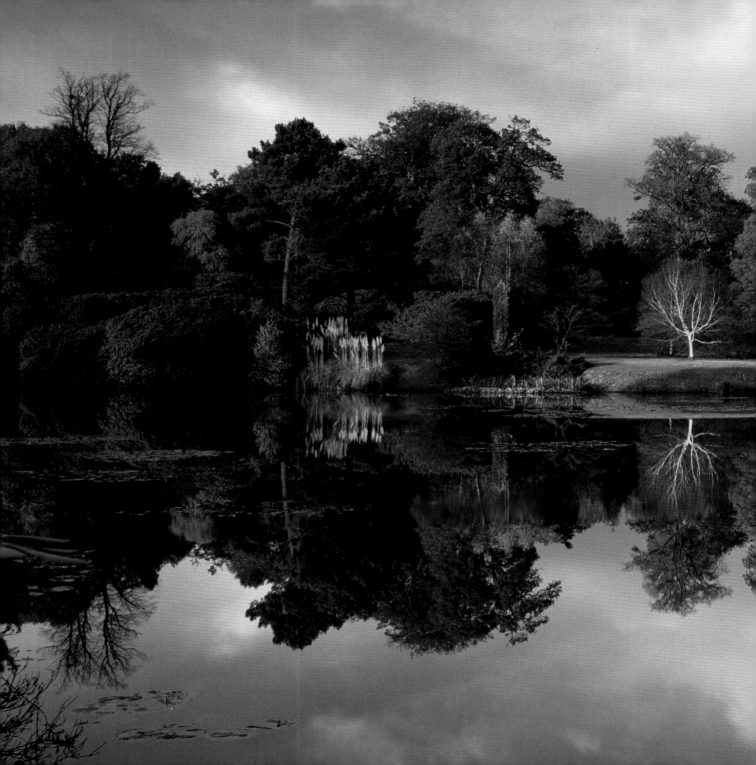

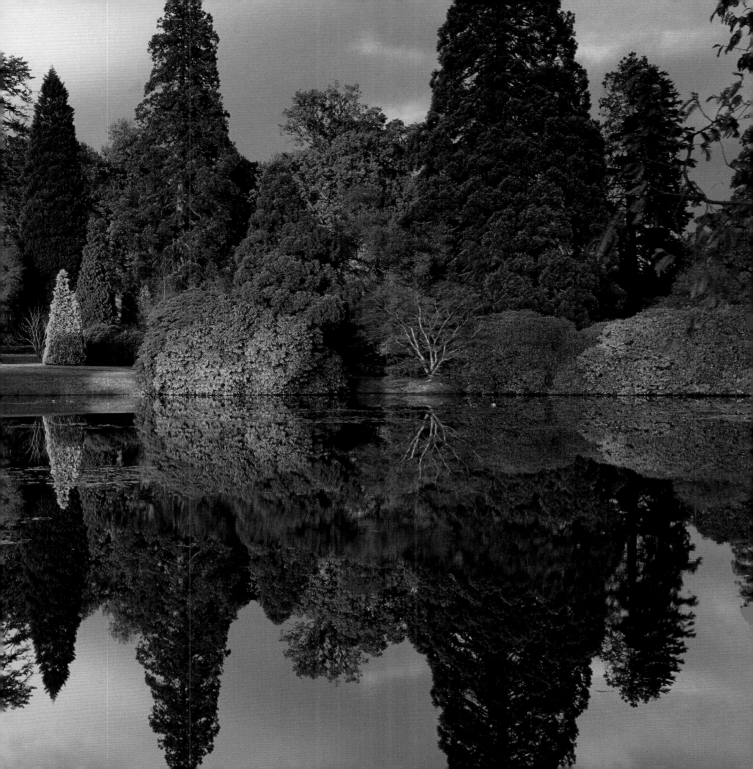

An ulterior motive

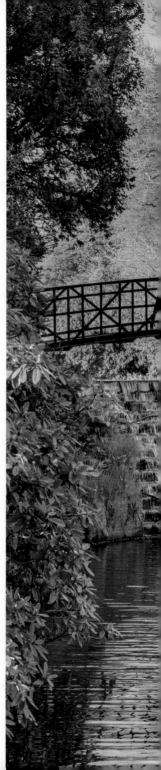

We do not know if the 3rd Earl was a great gardener, or if he found aesthetic pleasure in his trees and shrubs, the drifts of rhododendrons, and the giant redwoods which line the paths at Sheffield Park. Much of the planning of the pleasure ground was made by his groundsman and gardener, William Moore.

The 3rd Earl's grandfather, John Holroyd, had employed the great garden designers of the day to establish the family country seat; the land and surroundings would define his status and place in society. A century later, his grandson's ten-year programme of refining the great ponds and lakes

with their cascades and falls, clearing undergrowth and scrub, tidying footpaths and adding decorative planting was done with one end in mind. Contemporary reports are in no doubt that this hugely expensive and lengthy operation was undertaken so that the setting of the cricket ground was as lovely as possible.

A newspaper article appearing on the second day of that first visit by the Australians enthuses: 'The cricket ground within the Park is the most picturesque in England and among those who were present in their thousands yesterday probably few would be found to declare that they had ever seen a fairer sight than was presented by the ground and its surroundings.'

Left First Bridge at the top of Pulham Falls; the bridge was also built by Pulham & Son

Right 'Exciter bricks' creating a 'white water' effect

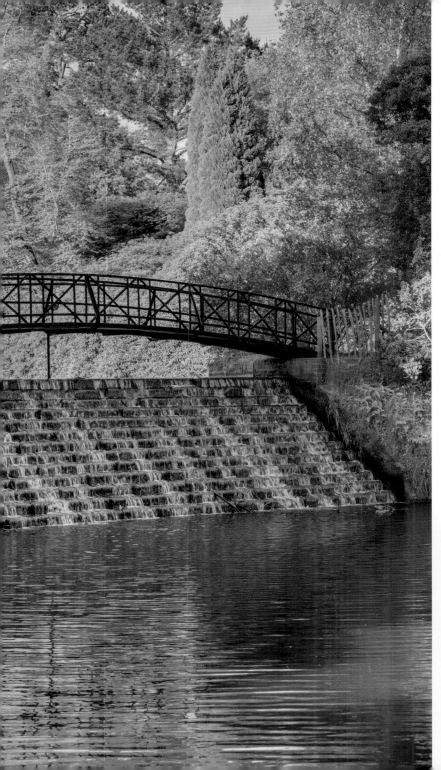

Cascades and 'exciter bricks'

Even the cricket-obsessed newspaper correspondents had to admit that one of the chief attractions of Sheffield Park was 'the noble expanse of ornamental water, with its pretty cascades and gently sloping banks'.

Reorganising Repton's series of pools into the Ten Foot Pond, its Upper Bridge overlooking the spectacular Pulham Falls, was a major feat of engineering and sheer hard spade-work. Making this pond, and the lower Middle Lake into which it flows, provided much-needed employment for around 150 labourers over the winter of 1882–3. They moved 600,000 tons of earth, digging down to the blue clay which was then 'puddled' by driving flocks of sheep through it. Before the water flowed back to fill the lakes, the clay was covered with thickly-spread gravel. This enhances the clarity of the water so that the reflections of lakeside plantings are perfectly mirrored.

Making the most of the water

A century earlier Capability Brown had divided the Woman's Way Pond so that the upper expanse of water, now fronting the cricket ground, flowed by way of a cascade into the lower water. A bridge spans that point where the division has been made. 'Exciter bricks', built into the cascade to interfere with the flow of the water and make it splash and sparkle, enhance the effect.

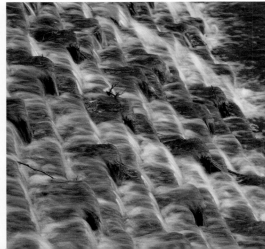

Moving water uphill

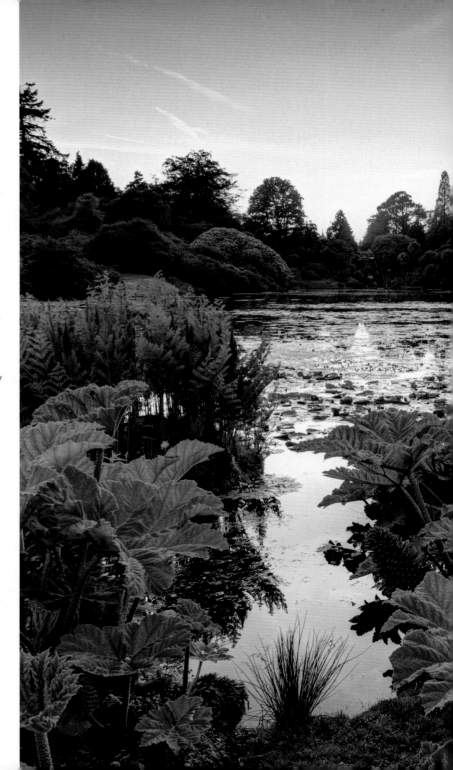

Victorian engineering supplied the energy for the Pulham Falls as a concealed 50 horsepower engine was connected to pipes that drew water through the ponds. Hydraulic rams moved water from the Lower Woman's Way Pond to fill a reservoir near the house.

Known as the Storage Pond, the reservoir was dug from an earlier fish pond and constructed to supply water for the newly planted gardens, the stables and the cricket pitch. It also acted as a water supply for emergency fire-fighting.

The area around the Storage Pond was thickly planted with trees and shrubs. Conifers, including the newly discovered giant redwoods, or *Wellingtonias*, were placed north of the lakes, bordering the paths and forming clumps on the rising ground. Seeds of the giant redwood had been collected in America by plant hunter William Lobb in the 1850s and Sheffield Park became one of the first great gardens in Britain to plant these magnificent trees.

Rhododendrons, azaleas and Japanese maples provided the colour that the 3rd Earl wanted to celebrate the spring opening of the cricket season. A small army of gardeners toiled around the Upper Woman's Way Pond, making a rhododendron-filled inlet and planting golden laburnum, white broom, ferns, silver cedar and hardy palms on the lower banks of the falls.

Right Sunset over Middle Lake, looking towards Pulham Falls

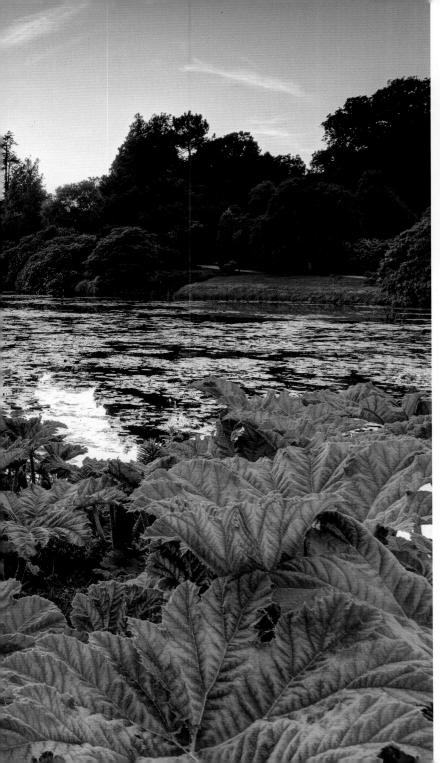

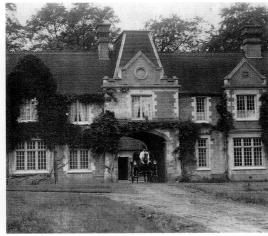

A home for the horses

Nothing escaped the 3rd Earl's attentions. Wyatt's mansion received new windows and a handsome entrance porch. Although today it is privately owned, the house, on high ground overlooking the gardens, is as much a feature as in the 1880s when overgrown trees were cut back to afford long views to the cricket pitch.

A magnificent new stable block was built around a central quadrangle and entered through an impressive Tudor archway which was allowed to remain. The Earl's stables could accommodate 18 horses and had four double coach-houses – an indication of the grand style in which he lived and entertained. Coachmen and grooms had their own apartments above the stables; there were seven bedrooms in all. The large indoor arena opening off the courtyard to the left of the Tudor archway was used for schooling, exercising and training young horses. In a later incarnation it was used as a theatre, for private productions. Today, it forms part of the National Trust tea room.

Above The Coach House is now home to the tea room and shop

A time of extravagant pleasure

Henry Holroyd, 3rd Earl of Sheffield, was a complex character. He loved beauty and was prepared to pay for it. His generosity to the community was legendary, yet if he felt he had been slighted he could withdraw his patronage instantly.

He did not marry, although tongues wagged in 1895 when he 'adopted' the daughter of the local vicar, persuading her to act as his hostess and social secretary. He was 63. Mabel Attenborough (known as May), was a young woman of 24. She remained his companion until his death in 1909, organising and hosting events at Sheffield Park and accompanying him on winter trips to Naples and the south of France.

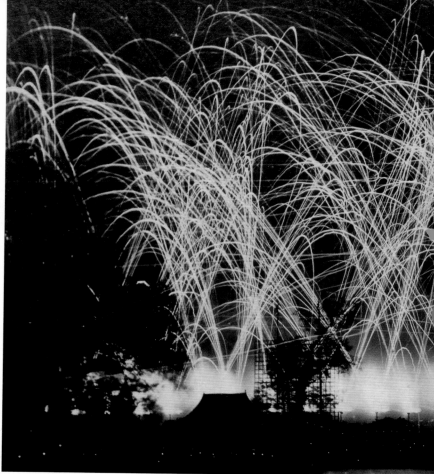

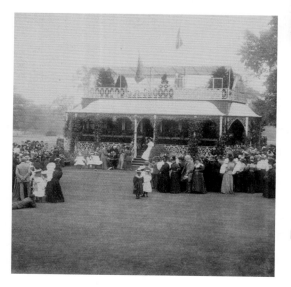

Henry loved to show off his country home, inviting thousands to the park to watch the cricket and enjoy refreshments at his expense. The Sheffield Park estate hosted the annual Root and Vegetable Show and the May Day celebrations. Bands would play at these special occasions, fireworks soared into the sky and all enjoyed wonderful food, drink and entertainment.

The 3rd Earl's extravagance, which went far beyond the landscaping and planting at Sheffield Park, was to eventually bankrupt his estate and leave it heavily mortgaged when he died.

Above The Earl would often hold parties and entertain his guests with huge firework displays

Left A prize-giving ceremony in front of Lord Sheffield's pavilion, c.1890

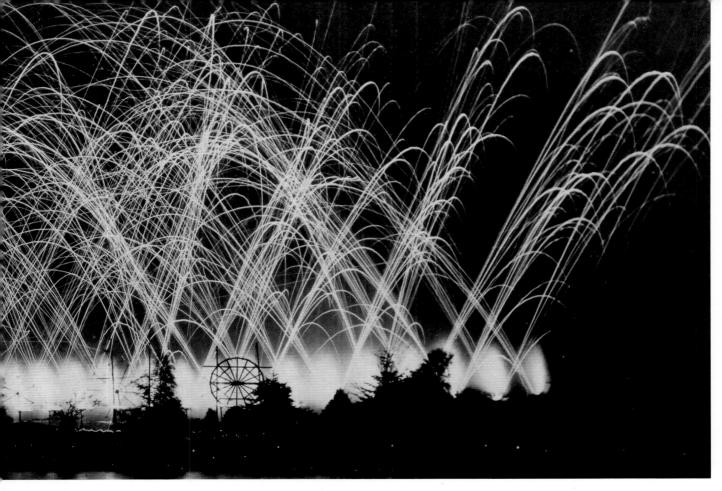

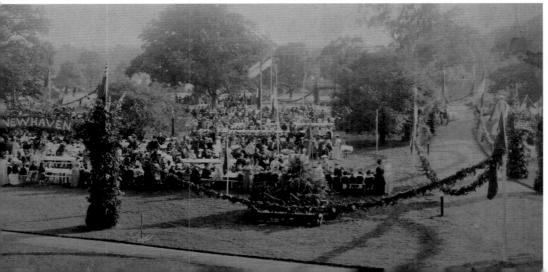

Left The Earl's annual summer picnic for children was once said to have tables that stretched to a mile long

Taking cricket to Australia

The 3rd Earl's largesse also extended to providing warm winter clothing for his labourers, tenants and their families and to paying large bills for church repairs. If his expenditure on charitable works seemed considerable, it was insignificant compared to the sums spent on fostering cricket. He dug deeply into his pocket during his three terms as President of the Sussex County Cricket Club, helping the ailing organisation back on its feet.

The biggest outlay was his extraordinary trip to Australia over the winter of 1891–2, when he bore the entire expense of taking an English team, captained by W.G. Grace, to play three test matches and five other first-class games, as well as some minor matches with local and regional teams.

It was during this tour that Henry presented a gift of £150 to the Australian cricketing authorities, which was used to purchase the renowned Sheffield Shield to promote competitive cricket between Australian states.

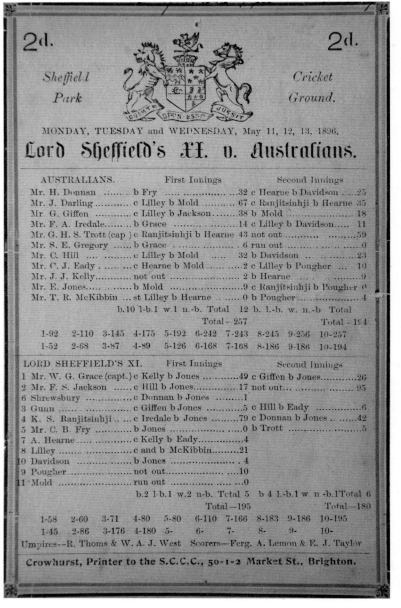

Above Score-card for
Lord Sheffield's Eleven
v Australians

Left The Prince of Wales
meeting W.G. Grace in 1896

A prince in the Park

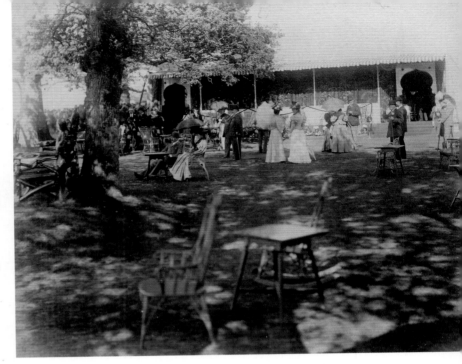

At precisely 11.30am on Monday 11 May 1896 a gleaming steam engine pulled up at Sheffield Park station. The locomotive bore the Prince of Wales's feathers. Flags and bunting decorated the platform where a guard of honour from the 1st Sussex Engineers stood smartly to attention. Outside the station, four grey horses stood, harnessed to a splendid state carriage.

A rotund figure stepped forward as the train stopped and the carriage door opened. Bowing, he removed his top hat. His royal visitor, equally plump, greeted him with a handshake. The band played as the Prince of Wales and the 3rd Earl walked to the carriage that carried them smartly along the one-and-a-half miles to the famous cricket ground at Sheffield Park. Cheering onlookers packed the roadside as the carriage passed under seven flower-covered arches, through the parkland and perfect garden to the pavilion where the Prince was to watch the first day's play between Lord Sheffield's Eleven and the Australian visitors.

Of all the splendid entertainment at Lord Sheffield's ground this was the most sumptuous. The *Sussex Express* correspondent reckoned that about 25,000 people had turned up to catch a glimpse of the royal visitor. Attendances were not so high on the second and third day's play although at least 13,000 watched as the teams drew in a high-scoring match.

The railway at the bottom of the garden

The Prince was able to travel to a station just yards from the entrance to Sheffield Park thanks to the Earl's persistence in pressing for a rail link between East Grinstead and Lewes. That a station was built, conveniently, just outside his domain, was his doing too. He called a meeting of local landowners and then talked to directors of the London to Brighton and South Coast Railway to ask for their help. That was at the end of 1876. Work started early in 1879 and the line opened in August 1882.

Henry Holroyd, 3rd Earl of Sheffield, died in the south of France in April 1909. The funeral, with military honours, a gun-carriage and firing party was splendid and solemn. Crowds turned out to witness the Earl's last journey to the family mausoleum at Fletching Church. He had been a complex man, so shy he would rarely allow himself to be photographed but so generous in his entertainment of hundreds of thousands of people in extravagant fashion at his country home.

Above Lord Sheffield and the Prince of Wales (in the centre of the photograph) in discussion during the cricket match of May 1896

A Passionate Plantsman

Arthur Gilstrap Soames, Eton-educated and wealthy, was passionate about plants. A visit to Sheffield Park in 1889 triggered an overwhelming desire to own it. Here water could be the magical element that transformed his planting into a garden of ravishing beauty.

He had to wait 20 years for his dream to come true. As one of the major creditors of the 3rd Earl, who died heavily in debt in 1909, Arthur Soames (pictured above) asked for first option to purchase. In 1910 he became the owner of the house, its park and garden and the wider estate.

Lured by the possibilities of water and the promise of a beautiful garden, Soames, in his mid-fifties, wasted no time. Roses, azaleas and rhododendrons were his first love, but from the moment the estate became his, he threw himself into breeding different types of shrubs and seeking out trees for the best autumn colour. For the first time at Sheffield Park, a garden was being created for its own sake by a man who knew and loved plants.

Appealing to the senses

The garden's new owner wanted his creation to entice all the senses. He sought out trees that would bring vivid autumn colour, consulting his friend Sir George Holford, whose father had established Westonbirt Arboretum. His visits to Knap Hill Nursery resulted in a collection of calico bushes (*Kalmia latifolia*) from which he bred the best pink forms of this lovely shrub. He probably chose many of his beloved rhododendrons from the same Surrey nursery. Another contact was the renowned tree and shrub expert Charles Sprague Sargent of the Arnold Arboretum in Boston, Massachusetts, who sent specimens across the Atlantic.

Arthur knew exactly what he wanted, ordering tupelos, amelanchiers, red oaks, liquidambars, acers, photinias and many other trees and shrubs displaying brilliant leaf colour, directly from nurseries. Many other great woodland gardens of the time were experimenting with new specimens brought back from the Far East and South America by intrepid plant hunters, but there is no evidence that Arthur took advantage of this trend.

First he enriched the exhausted land with hundreds of tons of top-soil. Guns were used to clear the rabbit warrens, while overgrown areas were cut back and new paths made.

Above (clockwise from top left) Japanese maple (*Acer palmatum*), witch alder (*Fothergilla major*), sweet gum (*Liquidambar styraciflua*), swamp cypress (*Taxodium distichum*), red oak (*Quercus rubra*), and silver birch (*Betula pendula*)

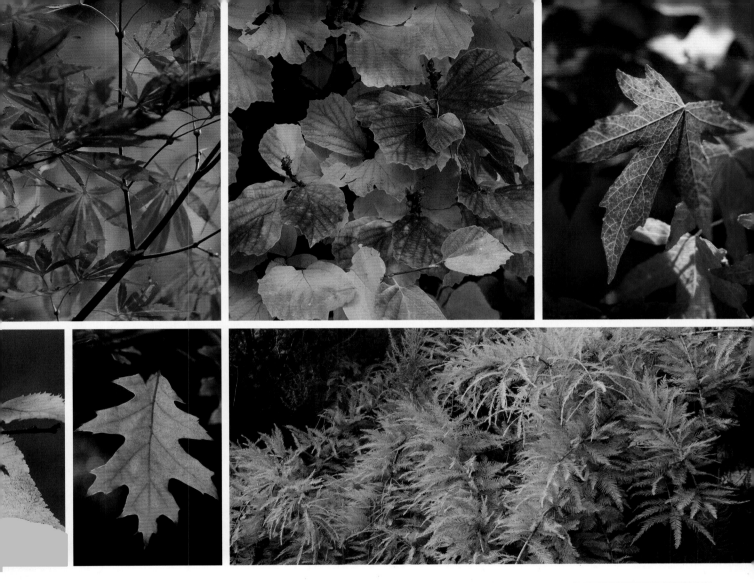

Restoring the house

Just as the garden was neglected and tired, so the great house, once considered welcoming and comfortable, was now cold and shabby. Arthur added an orangery, redecorated the rooms, and installed up-to-date plumbing and heating to make Sheffield Place fit for the house parties he planned.

The Baden-Powell connection

Arthur Soames' wealth was generated by the family brewing and malting business, which he oversaw with his brother, Harold, an artist. Harold's children included Arthur Granville and Olave St Clair Soames. Arthur Granville became heir to the Sheffield Park estate; Olave, who married Robert Baden-Powell, founder of the Scout and Guide movement, became Britain's Chief Guide in 1918.

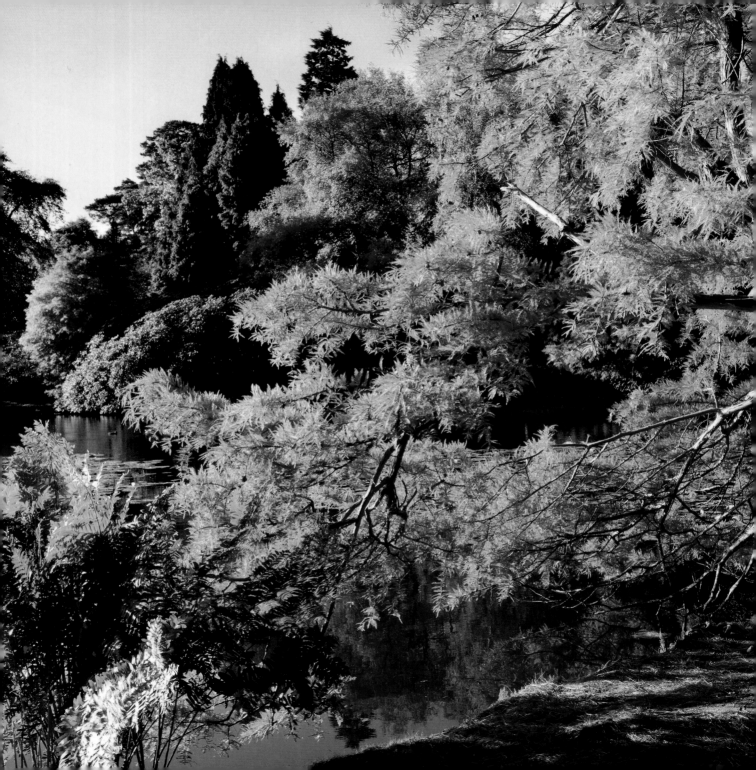

Seeking perfection

Arthur Soames was ruthless in his quest for the best colour in the garden. He was hands-on and thorough in noting the performance of his plants. In an article written just before his death in 1934, when he had gardened here for a quarter of a century, he notes: 'We had *Quercus palustris* (the swamp oak)… Although it grew very well, it showed not the slightest sign of colouring in the autumn, so we discarded it.' The oak, he later revealed, was in fact allowed another chance in a damper place.

In the same article, his description of the planting along the banks of Upper Woman's Way Pond reveals intimate knowledge of his garden. 'On the edge of the water are *Liquidambar*, Deciduous Cypress [*Taxodium distichum* or swamp cypress] a few *Amelanchiers* and clumps of *Berberis thunbergii*. The *Liquidambars*, with their toes in the water, colour better here than in a drier position. Higher up is a tree or two of *Acer ginnala* [now *A. tataricum*], which is generally the first to show colour. There are clumps of *Photinia variabilis* [now *P. villosa*], which when in colour is most brilliant… a few Scarlet Oaks, some Japanese Maples and *Nyssas*. Beside these are a few Conifers and Silver birch and many Rhododendrons… colour enough to make a very bright picture in the latter half of October.'

Left A swamp cypress turning vivid orange on the banks of Ten Foot Pond

A well-connected marriage

Photographs of Arthur Soames show a neat aesthetic-looking man, moustache clipped tightly, garbed in country tweeds. His features are fine, his eyes alert. Somewhat surprisingly, in 1919 at the age of 65, he married Agnes Helen ('Nellie') Peel, granddaughter of the former Prime Minister, Sir Robert Peel. Helen, a widow in her fifties, had distinguished herself in the 1800s with a thrilling account of her voyage through Arctic waters to the North Pole on the steam-yacht *Blencathra*. Her family was wealthy and well-connected. She and Arthur entertained as lavishly as Henry North Holroyd, the 3rd Earl.

'It would almost seem that the mantle of hospitality of the first Earl of Sheffield Park, and of his grandson the last Earl… has fallen upon the present owners of the place,' enthused the *Sussex County Magazine* in the 1920s, going on to explain, 'for they are never so happy as when they are sharing the delights of their beautiful home with countless friends'.

Entertaining royalty
Queen Mary, wife of George V, liked to come and eat strawberries and cream in the new conservatory. Queen Victoria's granddaughter Princess Alice and her husband the Earl of Athlone (Queen Mary's brother) paid several visits. In September 1942, after Arthur Gilstrap Soames' death, George VI, Queen Elizabeth's father, visited Sheffield Park.

Changing Seasons

Each season brings its own beauty to the garden. Some of the pleasures are hints of what is to come; others are delights evident only at one time of the year.

Winter's charms

A sunny winter's day throws the bones of the garden into sharp relief. Paths are clearly defined, a bend revealing a bridge or a watery glimpse. Stands of silver birch (*Betula pendula*) and brilliant red-stemmed dogwood (*Cornus sanguinea*) tempt you along the way. The lily-of-the-valley fragrance of yellow mahonia (*Mahonia japonica*) or the spicy scent of witch hazel (*Hamamelis*) waft across your path.

Before the deciduous trees are in leaf you'll see that many trees and shrubs are planted on mounds of soil, a technique first used by Arthur Soames to enable choice specimens to thrive independently of the local soil conditions. The deciduous swamp cypresses (*Taxodium distichum*), at the water's edge, exhibit a fine display of 'knees' or pneumatophores. The drooping branches of the weeping birch (*Betula pendula* 'Youngii'), planted by Arthur more than one hundred years ago, hang beside the Ten Foot Pond; frozen in graceful beauty they are waiting for longer days and warmth to trigger leaf growth.

Above First Bridge in the frost

Left Snow-covered witch hazel

The colours of spring

Masses of small native daffodils, heralds of spring, spread pale gold under the still leafless trees. When so many trees were ripped out during the hurricane-force winds of October 1987, Sheffield Park's bluebells all but disappeared because of the devastation to their habitat. Now they are back, carpets of misty blue, following the daffodils.

Here and there the early flowers of the star magnolias (*Magnolia stellata*) shine against the sky, while camellias come into bloom. But it is the banks of rhododendrons around the top lakes which reflect the true glory of spring.

Sheffield Park holds the Plant Heritage Collection of Ghent azaleas. They were 'rescued' from extinction by then head gardener Archie Skinner in the 1980s, under the auspices of the National Trust. Their fragrant honeysuckle-like flowers bloom late, at the end of May.

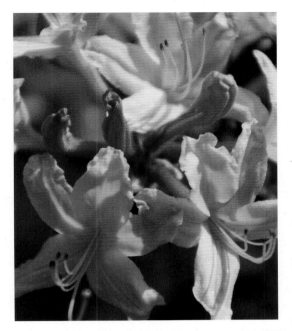

Above (right) Ghent azaleas

Right A carpet of bluebells underneath an oak

Dressed for summer

Summer brings swallows and dragon-flies chasing across the water, while water birds paddle among the water lilies. The sharp-eyed visitor might spot the turquoise and orange flash of a kingfisher heading for its bankside nest. Buzzards soar over the open parkland, and skylarks spiral upwards, tiny specks below the clouds.

The trees are dressed for summer; their young leaves have turned fresh green and fill the air with their whispery rustling. It is the trees, thousands of them, all glorious in leaf and often flower, that vie with the water for attention during the longest days of the year. The handkerchief tree (*Davidia involucrata*), white bracts aflutter; the large pale pink summer bells (*Chitalpa tashkentensis*); *Stewartia pseudocamellia*, with its camellia-like flowers; white-flowered *Eucryphia glutinosa*; and a rare shrubby *Juniperus macrocarpa* are just a few of the glorious specimens to be found.

Many are trees-in-waiting. Swedish birch, nyssa, wych alder, enkianthus, swamp cypress, acers, tulip trees, birch, hickory, red oaks, amelanchiers, euonymus and photinia will reach their full glory as their leaves begin to die. When the temperatures drop in autumn, they blaze with fiery red, orange and bright yellow.

Below Lower Woman's Way Pond with the cascade in the distance

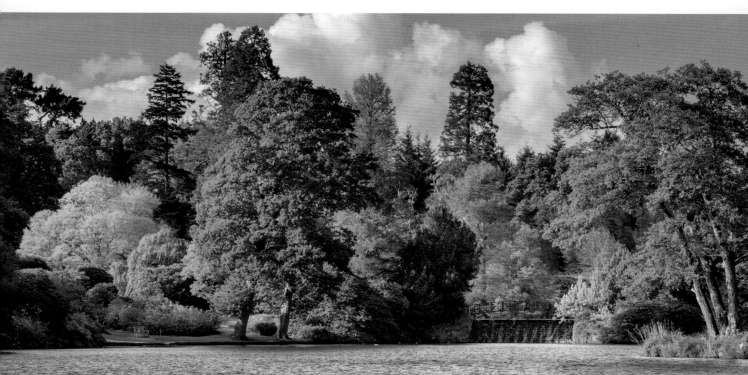

Autumn's fiery show

Above Tupelo (*Nyssa sylvatica*) in its striking autumn glow

Summer slips away slowly, as crisp morning sunlight picks out spiders' webs draped over the great stands of blueberries (*Vaccinium corymbosum*) which, by late October, will show fiery red.

Autumn is the garden's blaze of glory. Arthur Soames invested everything to ensure that the dying fall of the year would be achieved in brilliant colour. His herald was the pretty Sargent's cherry (*Prunus sargentii*), flaunting scarlet and red leaves in late September, summoning an equally splendid display from the many amelanchiers, bright in their rich red garb.

He regarded the tupelo (*Nyssa sylvatica*) as one of the most beautiful autumn sights. Many of his stalwarts are planted thickly along Brow Path which winds gently to a little hillock with a view of the house. Just as the spring rhododendrons paint the water with colour, so the fiery reflections of autumn seem to bring earth, air and water together.

Champion trees
Outstanding individual trees are awarded 'champion' status on the Tree Register of the British Isles. The champion must be the tallest, biggest-girthed or most remarkable example of a particular species. Sheffield Park has more than 80 champions, including an original tupelo (*Nyssa sylvatica*) 'Sheffield Park', planted by Arthur Soames and awarded its status for girth and height. It differs from others of the genus in that it colours ten days earlier with particular intensity. Discovered by former head gardener Archie Skinner, it is now commercially available.

Troops in the Park

Arthur Soames died in 1934. His widow, Nellie Soames, stayed on, entertaining her society friends, but the party ended as war broke out and the Park became home to thousands of troops.

Life changed for everyone. Troops were drafted in to build two large camps. Nissen huts filled East Park, the wooded land bordered on the west by Lower Woman's Way Pond, and more appeared across the water. For a while British soldiers – a Royal Artillery unit, detachments from the Royal Signals and Royal Army Medical Corps – occupied the huts.

At the end of 1941, two years into the war, Canadian troops arrived in large numbers. The impact on the quiet area was immense. The local children were fascinated by the foreign soldiers. Young boys hung around hoping for rides on military vehicles or to collect discarded Sweet Caporal cigarette packets with their prized 'cards' showing pictures of different aircraft.

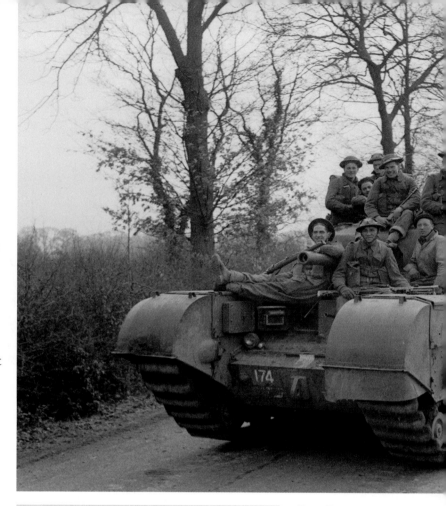

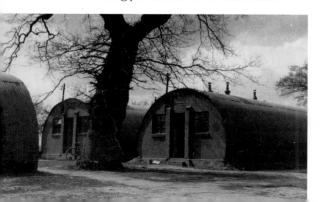

War-time recollections

A member of the Women's Auxiliary Air Force (WAAF) remembers: 'We were invited to Sheffield Park for a night of dancing and food. They had a live band. Sadly some of the men couldn't really dance that well... they had their heavy boots on. Lots of beautiful country houses around Sussex were commandeered by the Canadian troops for their headquarters, and they were wonderful places to go for the evening. We would all return by midnight in the back of a lorry.'

Above Troops on exercise in Sussex

Left Sheffield Park was covered in Nissen huts during the Second World War

The Canadians take over

Sheffield Place, still occupied by Nellie Soames, became the headquarters of the Royal Canadian Artillery in 1942. Six months earlier Le Régiment de la Chaudière, French-speakers from Quebec, had arrived to occupy the Nissen huts. Then came the 3rd Canadian Tank Regiment. These soldiers were all among the first to land in Normandy on D-Day, 6 June 1944.

Next to arrive were the Cape Breton Highlanders, a Canadian infantry regiment, who, on occasion, wore kilts. They trained in England for two years before fighting in Italy and northern Holland. Some of the units stationed at Sheffield Park took part in the 1942 raid on Dieppe.

One of today's gardeners, Alan Bradford, has strong family links with Sheffield Park. His maternal uncle and aunt were respectively gamekeeper and housemaid during the Second World War; his paternal great-uncle worked as a carter in the Soames era. The Canadians, accustomed to hunting wherever they liked back home, thought little of British poaching and used .22 rifles and shotguns to bag the occasional pheasant from the Park. Alan's uncle rumbled the hiding place of one of their weapons when he found a double-barrelled shotgun with a broken trigger, wrapped up and hidden in a stack of corded wood.

Right Canadian troops training on the parkland at Sheffield Park

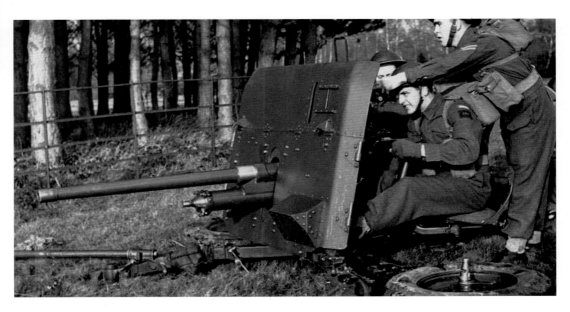

Tough training for Dad's Army

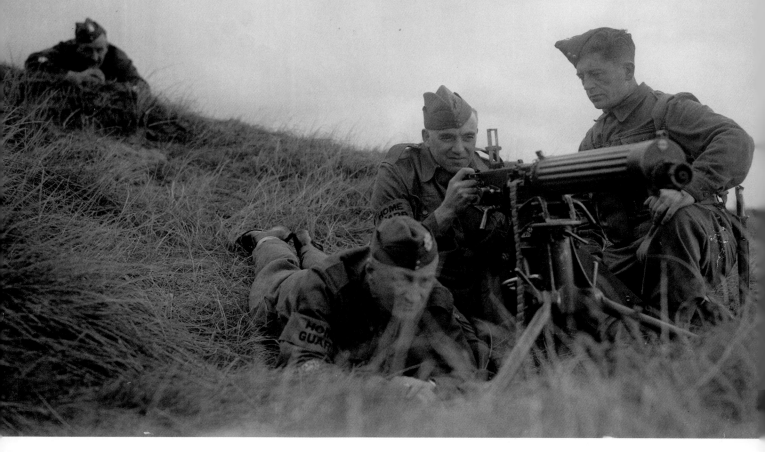

Above The Home Guard

The local 'Dad's Army', the Home Guard, trained with the Canadians – which turned out to be a pretty gruelling experience. South Park, at that time rough, with patches of brambles, bracken and gorse, was used for some of these sessions. They would practise with the anti-tank weapons, firing at sheets of galvanised tin, stuck into the ground.

There were about 20 men in the local unit; their families remember them speaking of 'real tough training'. They were given unarmed combat instruction and made to lie in trenches while tanks were driven over them or live ammunition fired just above their heads.

After the war, hundreds of spent bullets were found in the bank behind Upper Woman's Way Pond. It is likely that the troops used this area as a rifle range.

Getting on (mostly) with the locals

Other memories are more pleasant. Towards the end of the war, as threats of a German invasion lessened, the Canadians invited local people, especially the children, to an evening of entertainment. The youngsters were offered exciting rides over the rough ground on the parkland on Bren gun carriers and tanks. The Canadians were well-liked for the parties they gave for the children from the area.

But at times there was friction between the locals and the transatlantic visitors. The soldiers drank in the Sheffield Arms at Fletching where they suspected the beer had been watered; sometimes there were exchanges of views about this which turned physical. Once a French Canadian, whose beer clearly hadn't been diluted, came staggering out of the pub and bumped into a large local woman. So drunk was he, he mistook her for one of his friends and grabbed her. She thumped him with such force he fell backwards into a water-filled ditch. She said she heard loud swearing from the ditch all the way up the road.

Another soldier, a Cape Breton Highlander named Red Gordon MacQuarrie, an excellent violinist and piper, played his fiddle in the Sheffield Arms in return for drinks. One night, after being well rewarded, he lost his way back to camp and fell into a bog. He was completely covered with black mire and, after being rescued, was renamed Black Gordon.

A close encounter

The presence of so many Allied forces in East Sussex attracted the attention of doodlebugs and German bombers. One local man remembers, as a boy, walking up a path from the Upper Woman's Way Pond, where he had been fishing and looking up to see to his horror a German plane '...coming over very low. I could see the pilot with his leather helmet and goggles and I thought I hope to God he can't see me down here. He'll turn round and shoot me.' But the bomber had taken a hit and crashed nearby.

Below The Cape Breton Highlanders at Sheffield Park

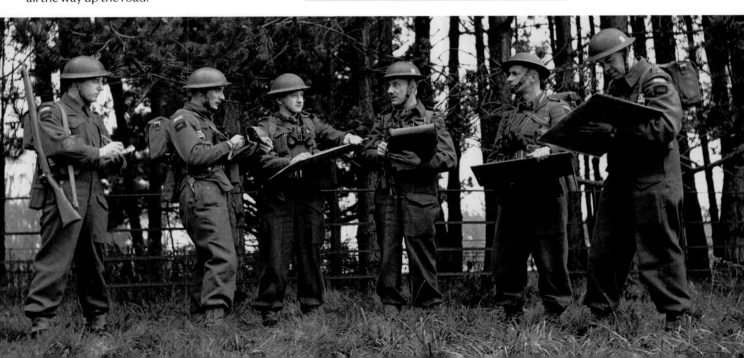

Reflections

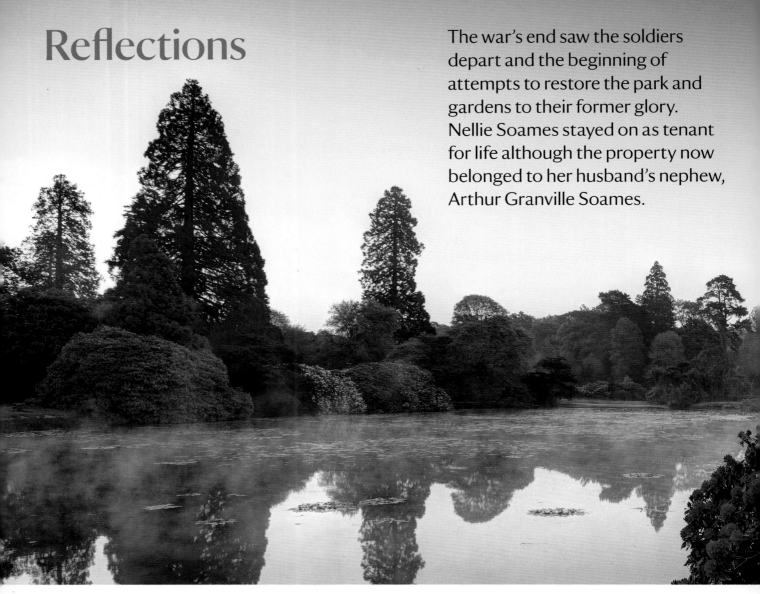

The war's end saw the soldiers depart and the beginning of attempts to restore the park and gardens to their former glory. Nellie Soames stayed on as tenant for life although the property now belonged to her husband's nephew, Arthur Granville Soames.

By 1945, Nellie was 80 years old and the extent of the wartime damage to the land and buildings was too great for her to cope with. In 1949 she surrendered the house and estate to her nephew who began restoration work. But he too gave up and, in 1953, sold the estate to a property company.

It is interesting to speculate what might have happened had Nellie Soames stayed at Sheffield Park until her death, as was her right under the terms of her husband's will. She died in London in 1964 just one year short of her 100th birthday. Arthur Granville Soames predeceased her by two years.

Above **Reflections on Middle Lake**

estate buildings and the farm land, passed into private ownership.

The clear-up begins

The task facing the Trust team led by Fred Dench, who had been Arthur Soames' head gardener, was overwhelming. Reedmace choked Middle Lake, while the Pulham Falls were in need of restoration. Everywhere the neglect of the war years was evident. Perhaps the most onerous task was the removal of the Nissen huts – although in many cases their foundations were left undisturbed.

The Trust, as successors to those who had made these beautiful gardens, agreed that the historic and aesthetic aspects of what went before should be maintained. The blaze of autumn colour which had been the focus of the first Arthur Soames' plantings, should still be the climax of the year.

The large conifers, that are so much a feature of the gardens, have been maintained and added to along Big Tree Walk, while those forming a collection of special botanical interest are kept together in Conifer Walk in the central part of the garden.

Restoration and acquisition

In 2007, the year that the cricket pitch was restored thanks to financial support from members and donors and play resumed, the Trust was able to buy more than 100 hectares (250 acres) of original parkland to the south-west of the gardens. Bounded by the River Ouse and the A275, South Park contains the remains of Irongate Lock, built by the 1st Earl of Sheffield to allow the transport of coal and other goods along the river.

Sheffield Park, the estate, house, parkland and garden of enormous historical importance, was a property ripe for the National Trust. But funds in 1954 permitted only the purchase of 81 hectares (200 acres). This encompassed the garden, and a few acres of derelict land near the entrance drive. The mansion, many of the

Renewal and a deadly blow

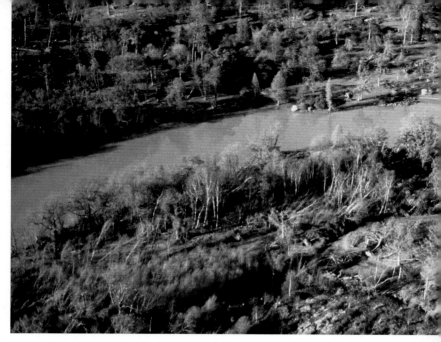

The Trust began to make headway with their plan for the garden. A massive overhaul of the trees saw the removal of old and dangerous specimens, while others were pruned and cuttings taken to ensure continuation. Hydrangeas were planted, paths gravelled and views reopened.

Rhododendron and azalea expert, Archie Skinner, took over from Fred Dench as head gardener at the beginning of the 1970s. He oversaw the establishment of bridges over the streams feeding the Upper Woman's Way Pond. These give views across the wildlife-rich marshland, which supports many species – including dragon-flies and damsel-flies to kingfishers. A stream garden was made and eventually the National Collection of Ghent azaleas, with their soft colours, large flowers and wonderful scent, was established during the 1980s.

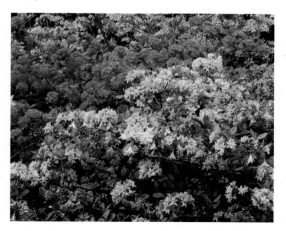

The great storm

In the early hours of 16 October 1987 the landscape that had been brought back with such care was devastated. In a few hours, hurricane-force winds of 100mph changed the shape of the Grade I garden, ripping out 2,000 trees, stacking them in heaps and tossing them into the water as if they were matchsticks. Gardeners arriving for work struggled to find their way as they clambered over fallen trees.

Woodland plants, sheltered for centuries by the canopy of the mature trees overhead, were suddenly exposed to the elements. Areas of dappled shade which once supported swathes of bluebells became grassy expanses, changing the ecosystem of the garden.

The devastation was so extreme that in 1991 a planting project was launched to re-establish the density of the trees and shrubs. Donations worth £360,000 were raised for *Planting for the Future* which enabled the team to plant new native and exotic trees to provide shelter and give long-term structure and protection to the garden. Eventually the beautiful bluebells started to return.

Above An overhead view of the devastation following the 1987 storm

Left Ghent azaleas

Opposite (above) Skyglade on the parkland

Opposite (below) Swamp Bridge at the end of Upper Woman's Way Pond

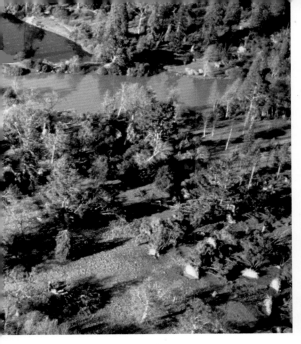

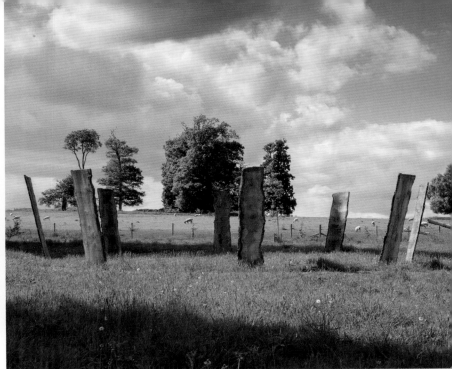

Enjoy the estate

Visitors are encouraged to enjoy all that the estate
has to offer. The less formal parkland of South
Park has four walking trails plus a play trail for
children. Ringwood Toll, a copse that may have
been created by Capability Brown, invites children
to climb fallen trees, build dens, negotiate
tree-stump steps and enjoy log see-saws.

Nearby is Skyglade, an oak-tree copse with
a viewing circle, fashioned from 12-foot-high
panels of natural oak. Go inside to watch the
clouds during the day and the stars at night.

Maria Holroyd and her father, the 1st Earl,
would recognise these clumps of trees. Maria
would shiver at the sight of the old Irongate
Lock on the Ouse where she and her family
narrowly escaped drowning on a boating outing
in 1794. They would be amazed at the tooting
whistle and clouds of steam from the nearby
Bluebell Railway, which replaced river
navigation in 1882. Their descendant, the
Victorian 3rd Earl, might also be surprised to
see 'his' railway still in action.

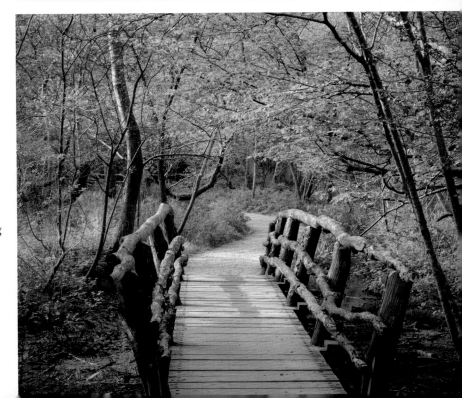

Two troublesome trees and a flood

The millennium started badly for Sheffield Park. The Trust, which had by then managed the park and garden for nearly 50 years, discovered that millions of gallons of water were leaking from Ten Foot Pond.

The culprits turned out to be two magnificent swamp cypresses (*Taxodium distichum*) whose roots were the cause of the trouble. Worse was to come. On Boxing Day morning, 2001, while the leak was still being remedied, the cascade between the Woman's Way Ponds collapsed; the bridge fell away and the water from the Upper Pond flowed out through the Lower, to disappear into the fields beyond.

The flood delayed the implementation of *Planting for the Future*, a five-year development plan designed to take a hard look at each area of the garden in turn. The plan envisaged the removal of dead and dying material and the planting of thousands of trees and shrubs to replace those lost in 1987.

With this plan, the Trust wanted to paint a picture, as had their predecessors, rather than separate the species into botanical groups. The tradition at Sheffield Park had always been to plant primarily for the impact trees and shrubs could make.

Tea in the stables

More than 4,000 trees and shrubs were planted in the first decade of this century. By the time the new planting was in place, another piece of the original estate had been bought by the Trust: the whole of the late 1700s stable block. The 3rd Earl's extravagant complex, the size of a substantial house, and entered by the Tudor archway, had been sold off in separate lots. In 2013 the atmospheric Oak Hall, once the indoor riding ménage, became the last part of the stable block to pass into Trust ownership. While some of the rooms are used as offices, here the secondhand bookshop, tea room, restaurant and gift shop can also be found.

The Hall, panelled in carved oak and furnished with an impressive stone fireplace, is now part of the Coach House Tea Room. It is not too difficult, while sipping tea and eating cake in this lofty room, to imagine the thudding hooves and steady breathing of the young horses being put through their paces in the arena.

A new source of energy
The Pulham Falls, the sparkling waterfall between Ten Foot Pond and Middle Lake, are beautiful to watch but expensive to operate. The falls are switched on for a few hours each week, until a new, more energy efficient, way of pumping the water, can be installed.

Right The Pulham Falls in full flow